Darwin's Pigeons

Volume 1

Darwin's Pigeons

An introduction by
Dr. Michael D. Shapiro

We tend to regard pigeons as ubiquitous and bland, as a threat to clean windshields everywhere. They inhabit our cities in massive numbers, a testament to their resourcefulness and our (unintentional) hospitality: our tall buildings and highway bridges, replete with shelter and ledges for roosting and nesting, mimic their natural habitats on steep rock faces.

Another side of the story is that the pigeon is one of the most successful avian species in the world, both in terms of its distribution and its diversity. You might be surprised to read that the pigeon varies in more kinds of characteristics than any other bird species, and that, like the many breeds of domestic dog, pigeon diversity was driven by careful breeding according to human preference. Pigeons were initially domesticated at least 3000-5000 years ago, and breeders have since selected for dramatic differences in behavior, vocalizations, skeletal morphology, feather ornaments, colors, and color patterns in hundreds of breeds. Pigeon breeding remains a popular hobby worldwide, and hobbyist organizations currently recognize over 350 different breeds. You might also be surprised to hear that the remarkable story of pigeon domestication and selective breeding inspired Charles Darwin's radical idea about how evolution works in wild populations and species.

When we think of Charles Darwin and birds, we typically turn to the Galapagos finches that bear his name; however, as the evolutionary biologist Stephen Jay Gould noted, *"Darwin's finches are not mentioned at all in the Origin of Species (1859); the ornithological star of that great book is the domesticated pigeon."*

Indeed, Darwin was a true pigeon aficionado, and he repeatedly calls attention to the spectacular diversity of domesticated pigeon breeds in Origin of Species and other writings. *"Believing that it is always best to study some special group, I have, after deliberation, taken up domestic pigeons,"* he wrote. *"The diversity of the breeds is something astonishing."*

Darwin contends that the differences among breeds within this one species are so great that an unknowing ornithologist might be tempted to classify them as different species. Despite the profound variation among breeds, Darwin also knew that even wildly dissimilar pigeons could produce viable offspring, and thus belonged to the same species. He proposed that they were all descended from the "blue" rock pigeon, a common type that inhabits virtually every urban setting on earth, but is only native to Europe, northern Africa, and southern Asia.

To Darwin, the enormous variation among fancy pigeon breeds provided a familiar example of how the process of artificial (human-directed) selection produced breathtaking diversity among organisms descended from a common ancestor. He argued that natural selection operates by the same basic rules, and was therefore the fundamental mechanism of evolutionary change in the wild.

The rock pigeon is generally held in low regard by most ornithologists (and people in general), but this species holds unique significance in the history of evolutionary thought. Pigeons also offer key advantages to unravel the embryological and genetic origins of diversity using modern molecular biology.

Pigeons are a geneticist's dream in that they display incredible diversity, yet all belong to the same species. In my laboratory at the University of Utah, we use pigeons to identify DNA changes that lead to changes in color, plumage patterning, growth, behavior, and a multitude of other traits. Remarkably, we are finding that changes in certain genes in pigeons also control similar traits in other animals, and even play a role in human disease.

For example, the same gene that controls the reversed crests of feathers on the heads of some pigeon breeds also controls crests in the ringneck dove, a species separated from pigeons by tens of millions of years. Changes in this same "crest" gene in humans are also associated with certain cancers.

These and many other studies by geneticists and developmental biologists point to a shared "toolkit" of genes that controls embryonic development in virtually all animals. By understanding how this toolkit is tweaked in pigeons, we can enrich our understanding of how these important genes contribute to both adaptation and disease in other animals, including ourselves.

As you peruse the pages of this book, you'll quickly understand why Darwin was captivated by this fascinating and charismatic species. Everyone, regardless of ethnic background or place of origin, knows about pigeons. However, this might be the first encounter with fancy pigeons for many readers, and you are most fortunate to have Richard Bailey as your guide.

Richard's photographs are remarkable not only for their technical skill, but also for the personality he infuses into each image (we must also give a little credit to the pigeons for their innate charm). He masterfully captures their splendor and playfulness, and you should be forewarned that this book might inspire you to take up pigeon breeding as a hobby. You might even want to try some breeding experiments of your own, and this might not be such a bad thing; after all, the hobby worked pretty well for Darwin.

Michael D. Shapiro, Ph.D.
Department of Biology
University of Utah
Salt Lake City, UT USA

American Show Racer

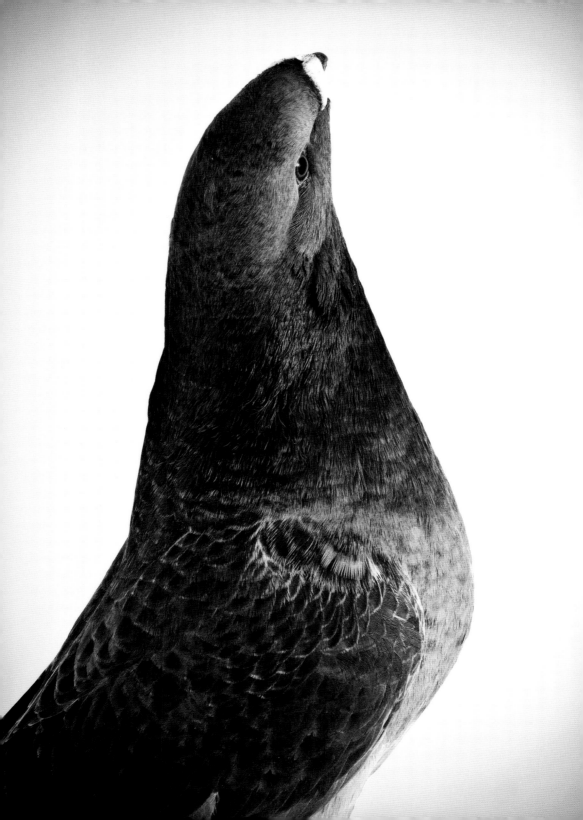

American Show Racer

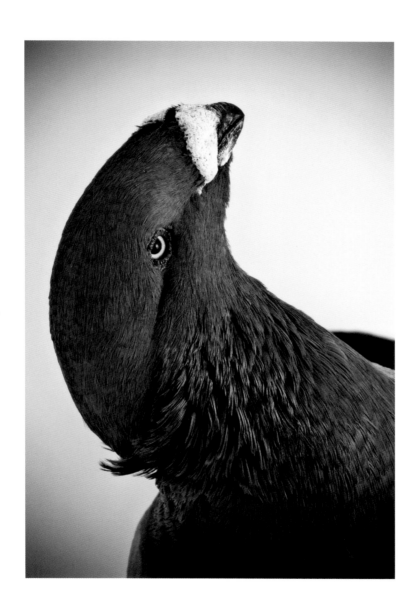

Dragoon

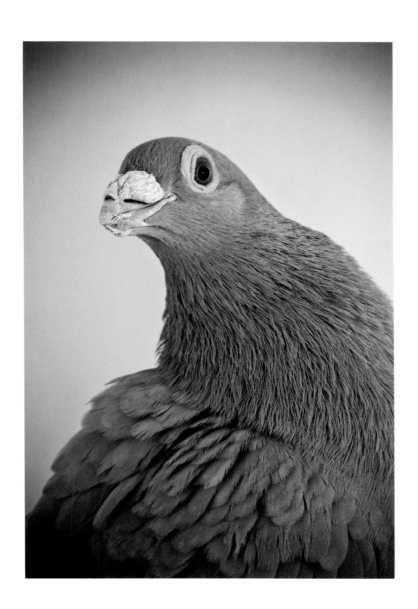

German Moorhead

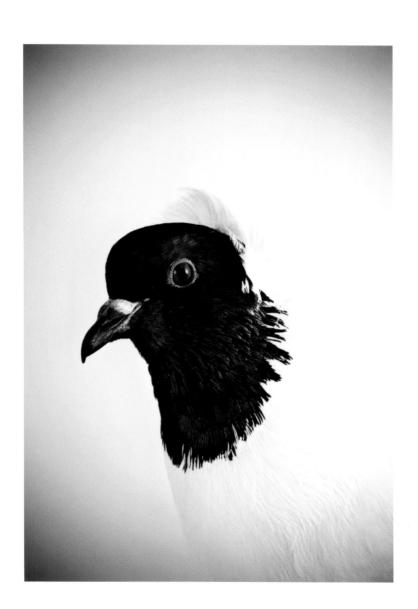

English Carrier

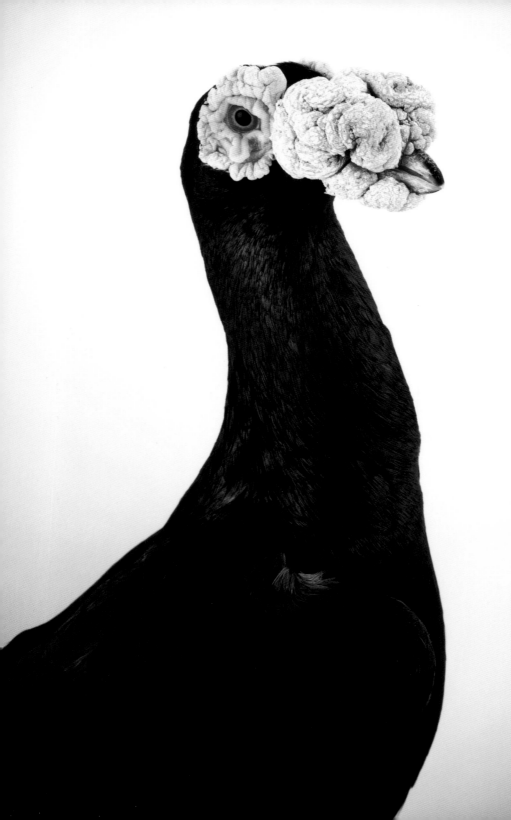

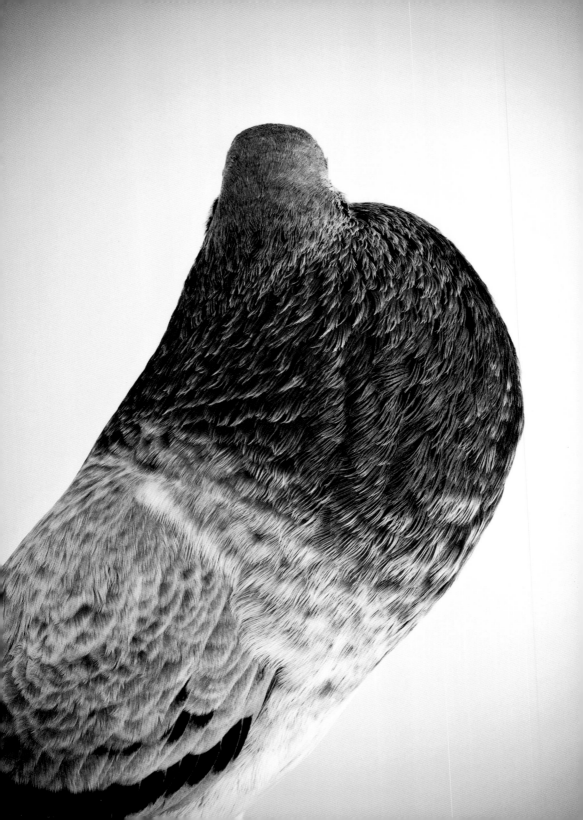

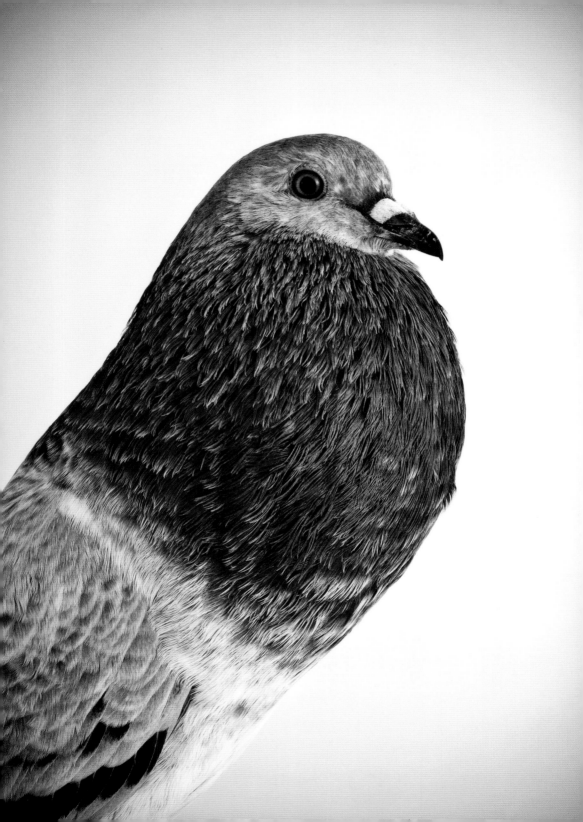

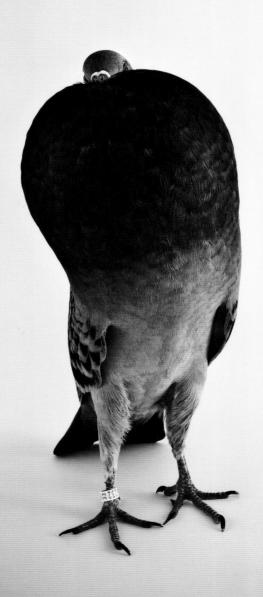

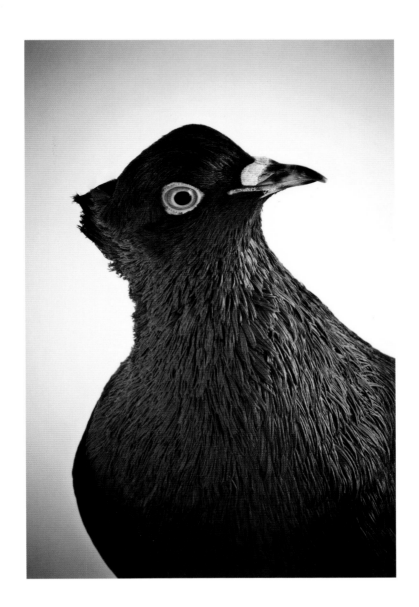

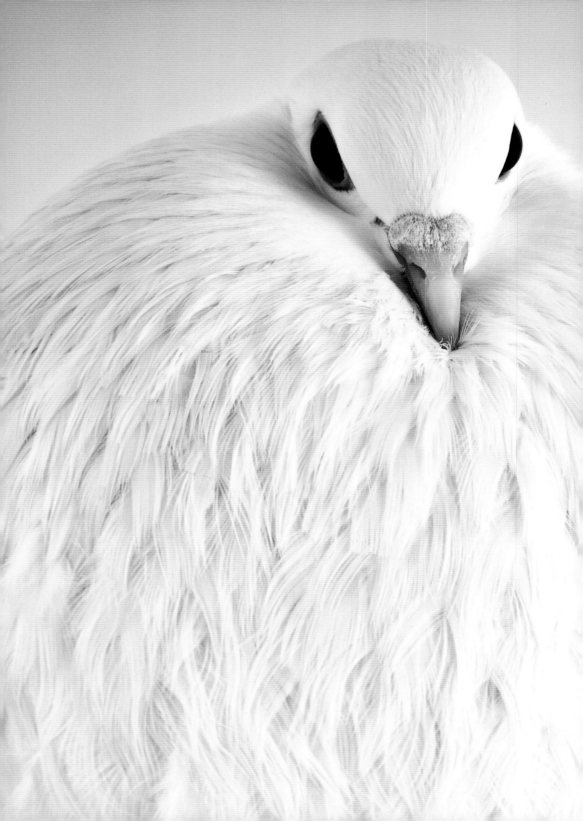

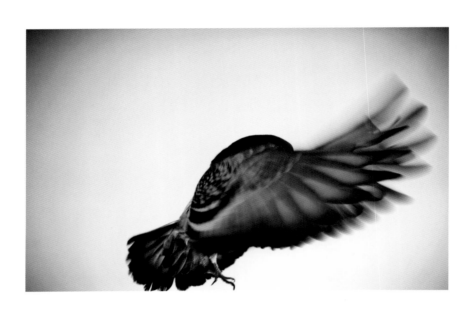

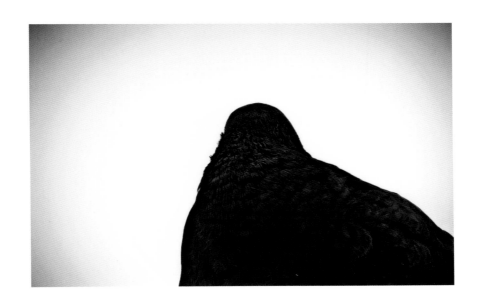

Old German Owl

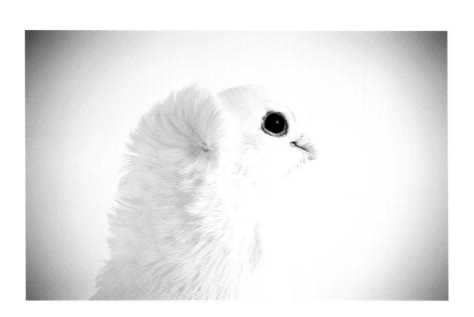

Blue Lace Blondinette

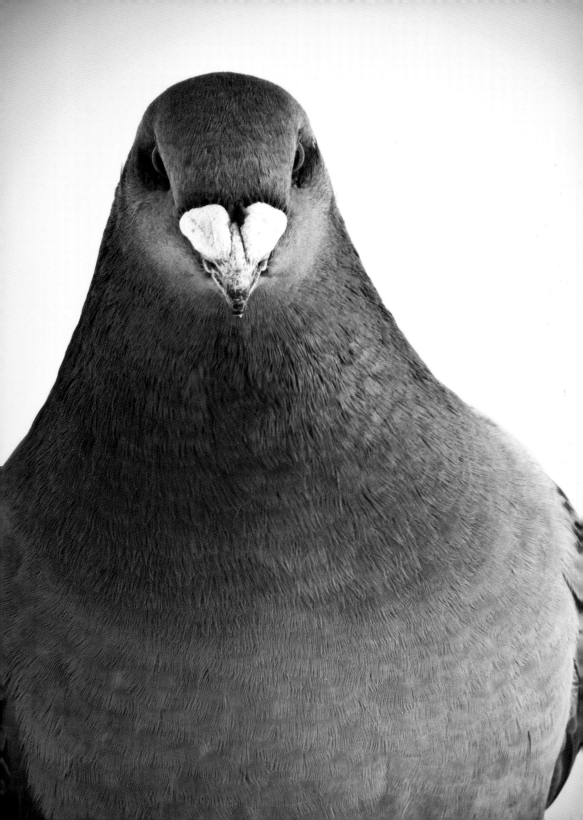

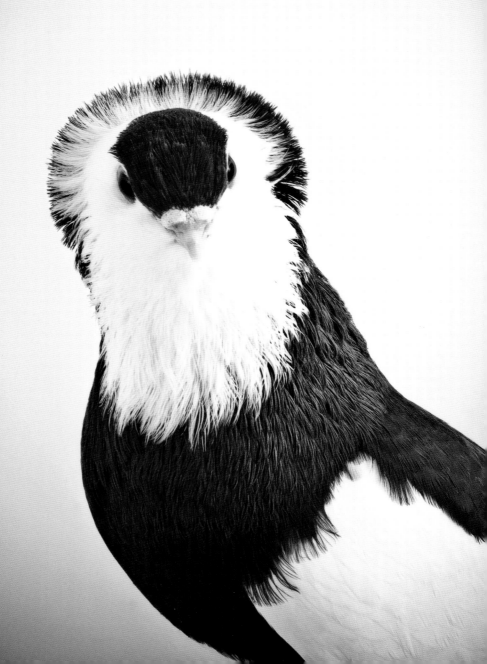

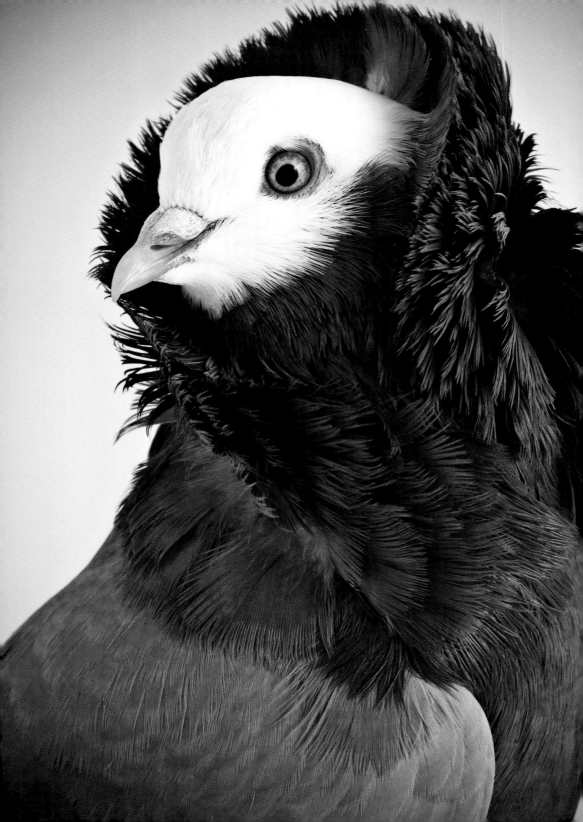

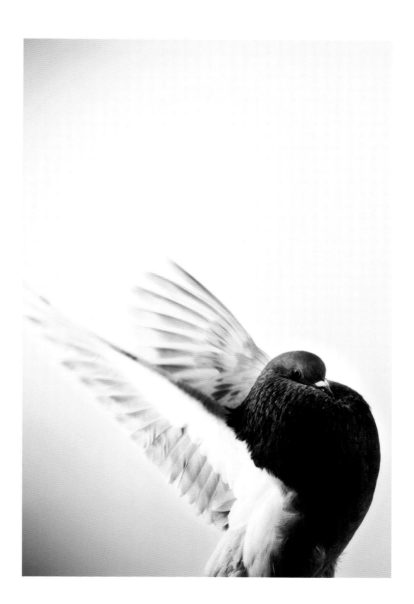

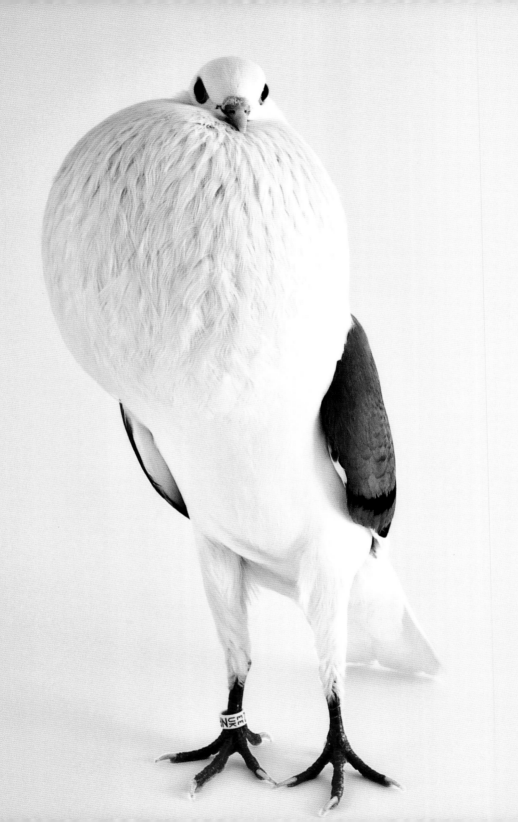

African Owl

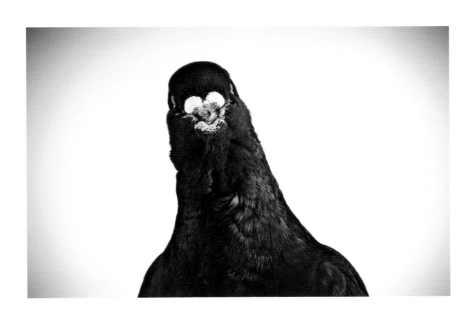

Magpie

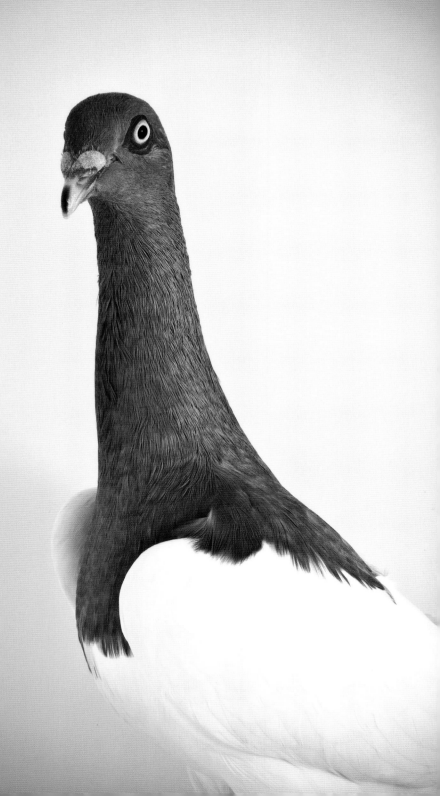

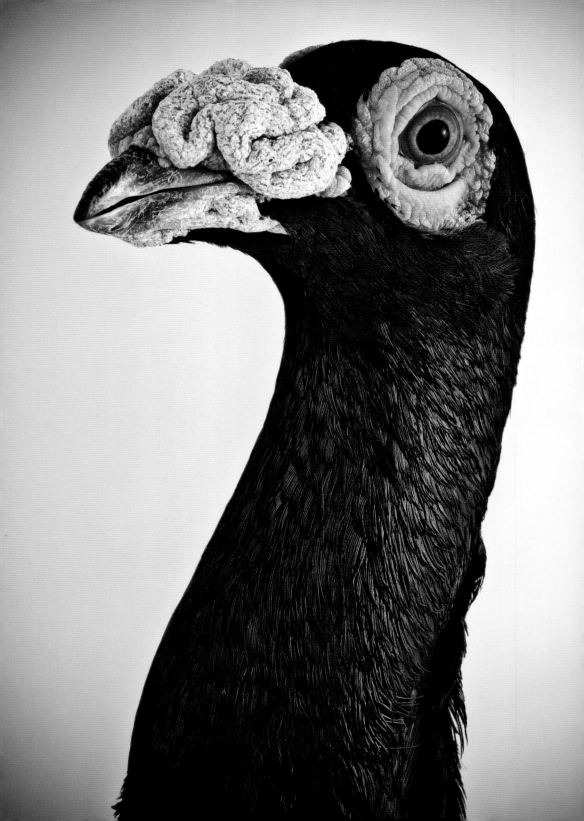

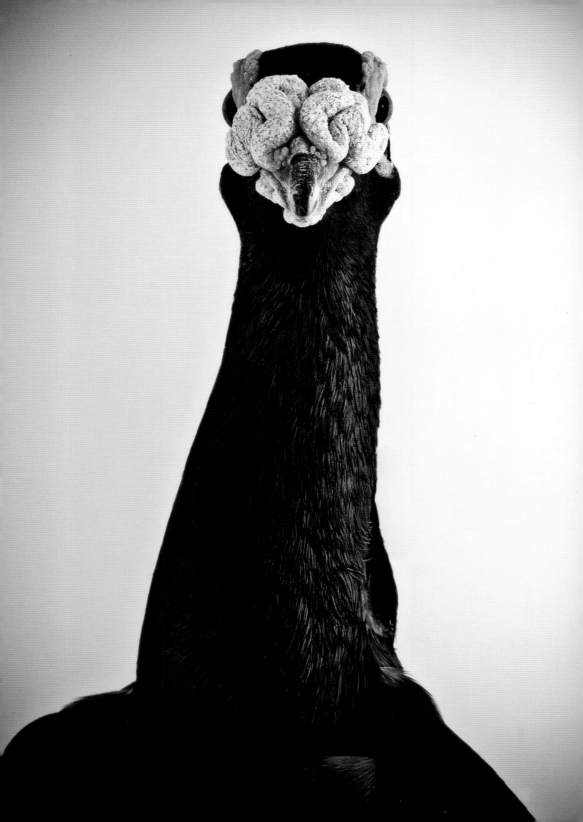

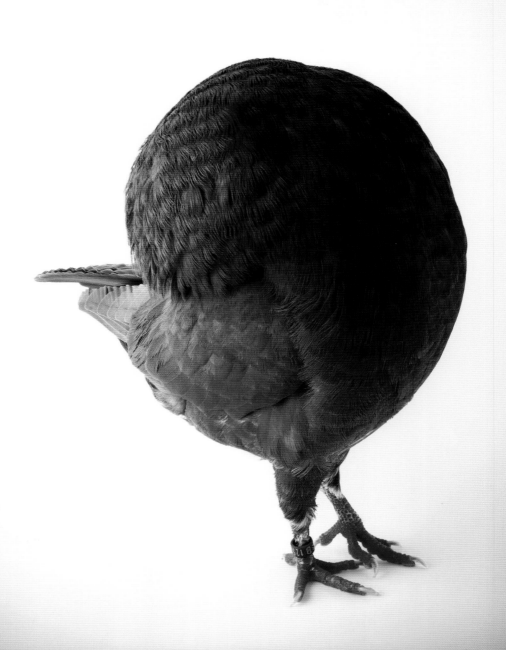

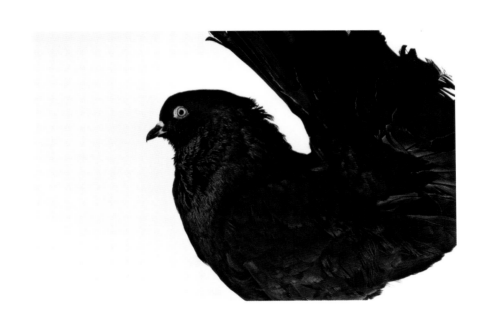

Marchenero Cropper

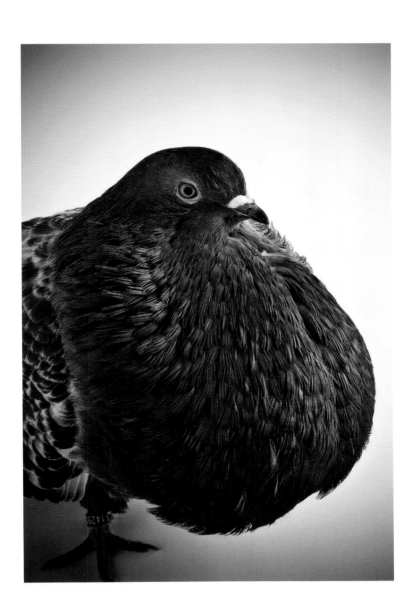

Archangel

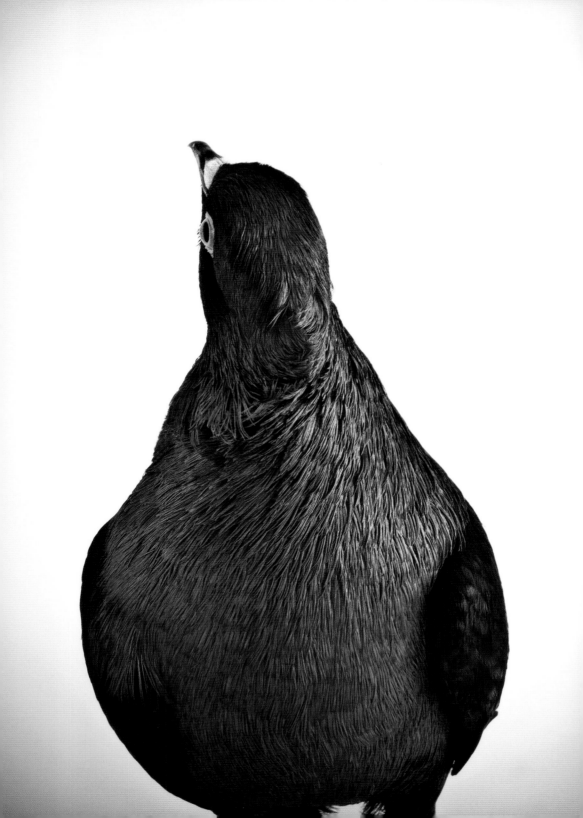

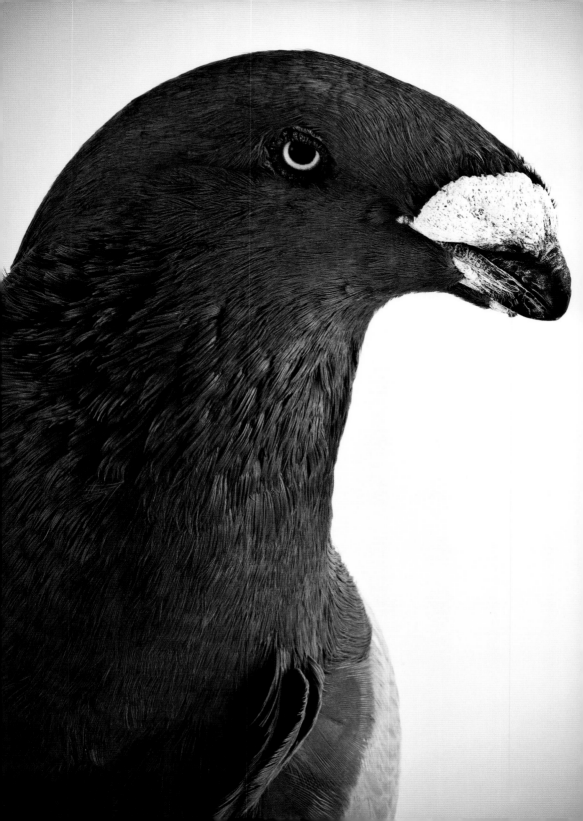

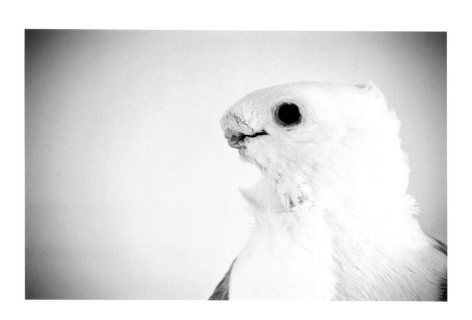

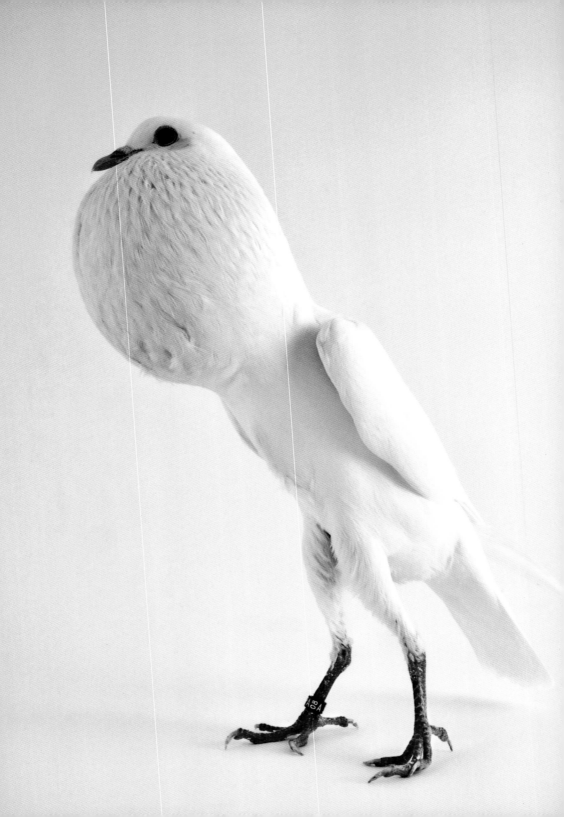

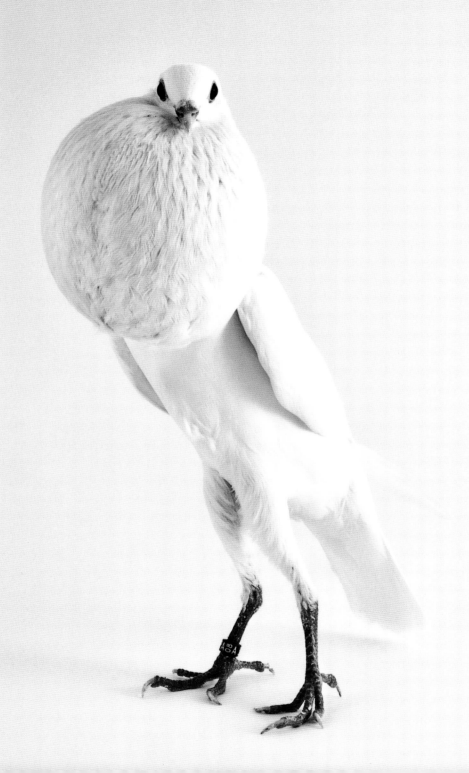

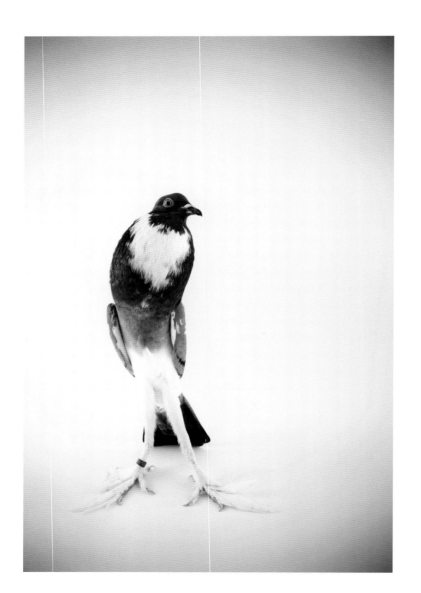

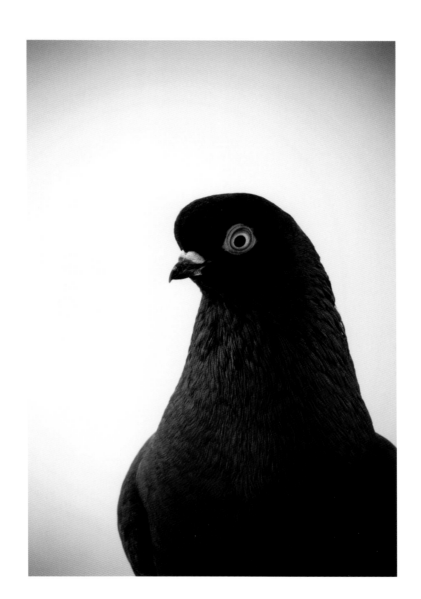

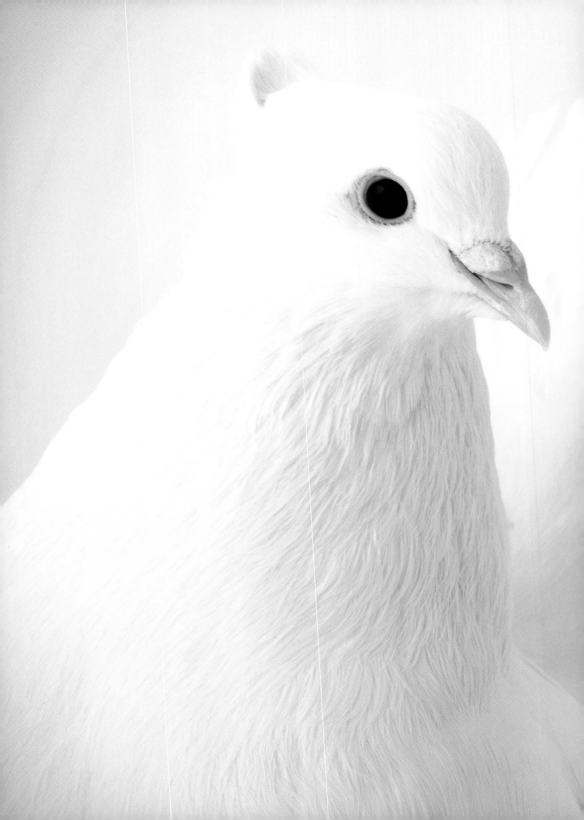

Black Jacobin

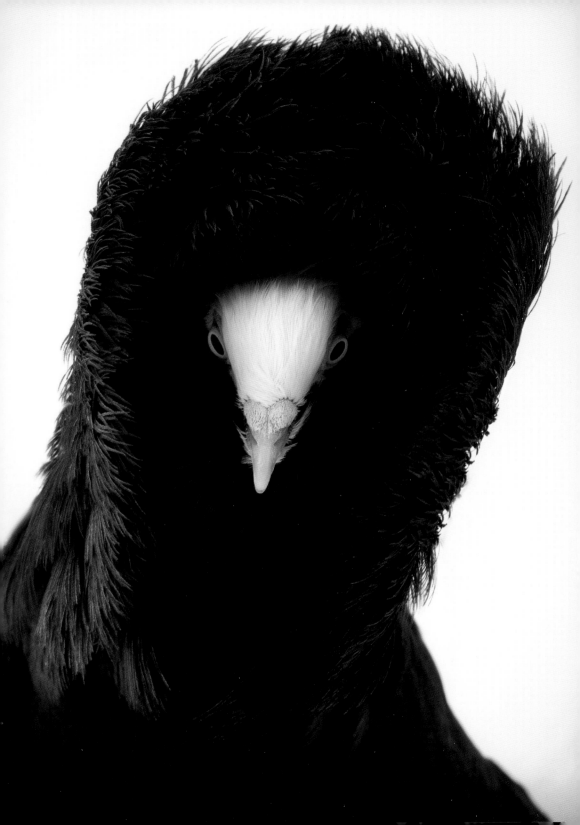

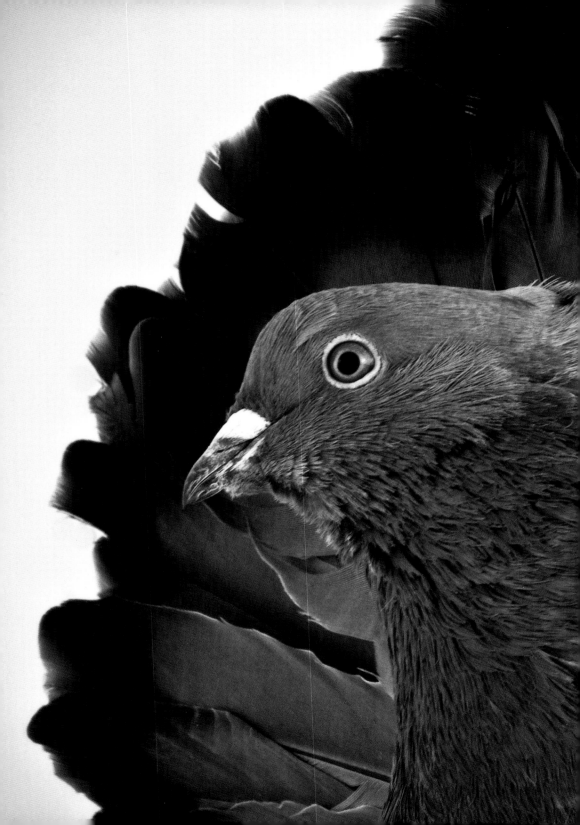

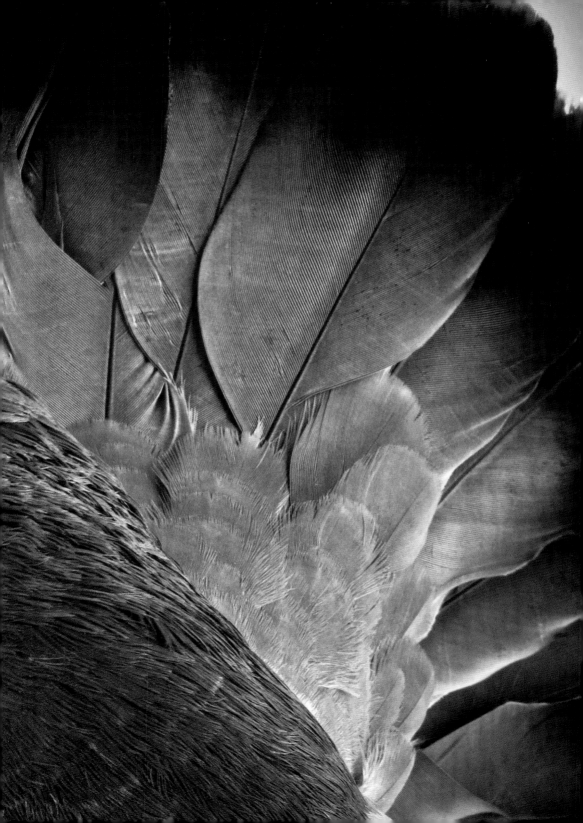

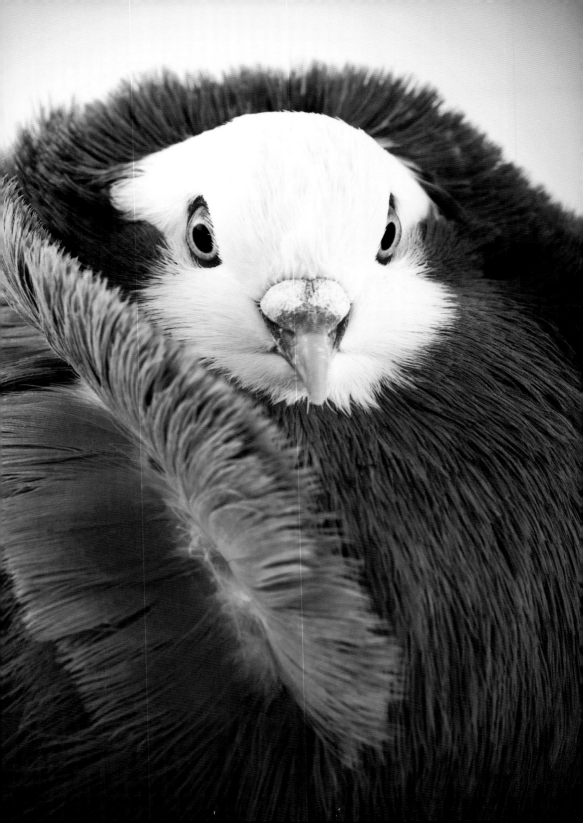

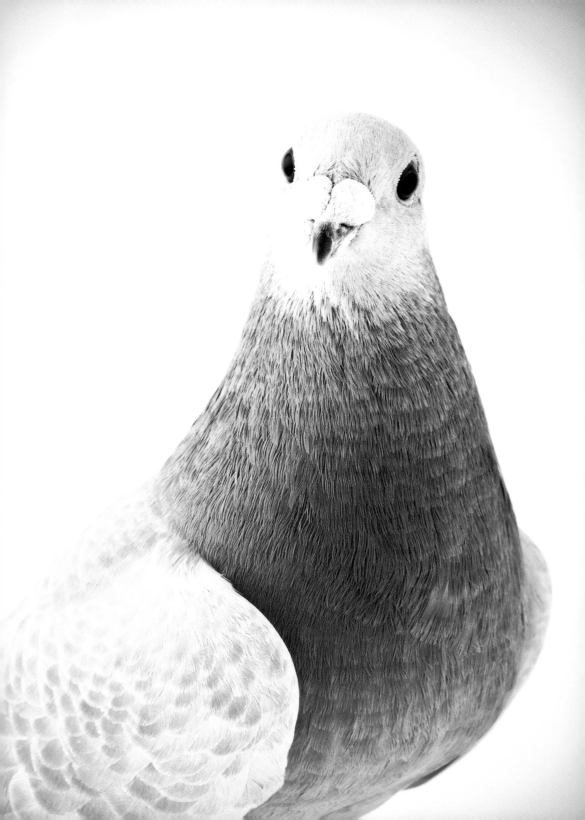

Old Dutch Capuchine

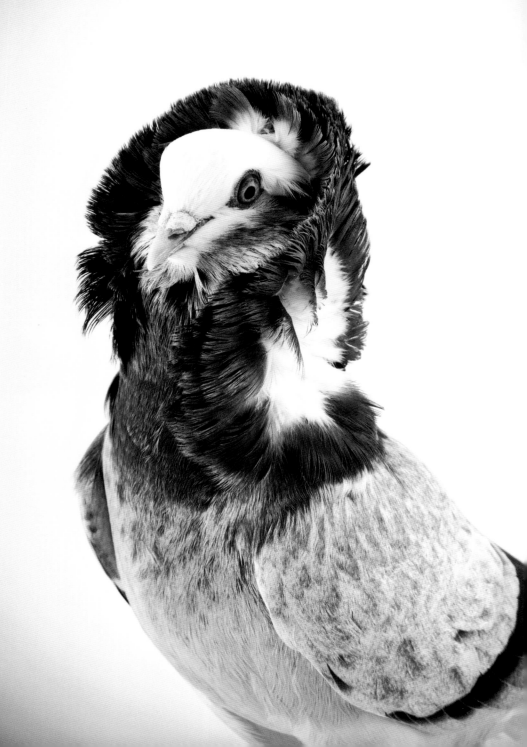

American Showracer

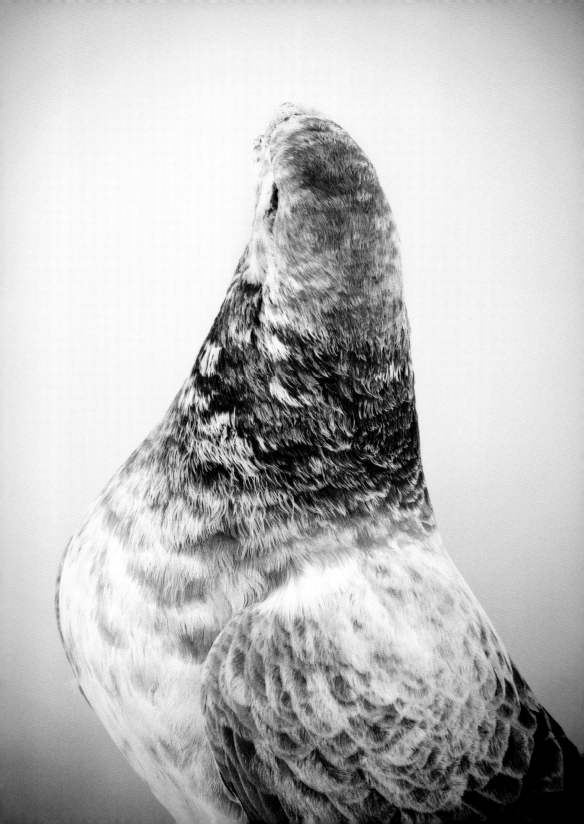

Blue Grizzle Frillback

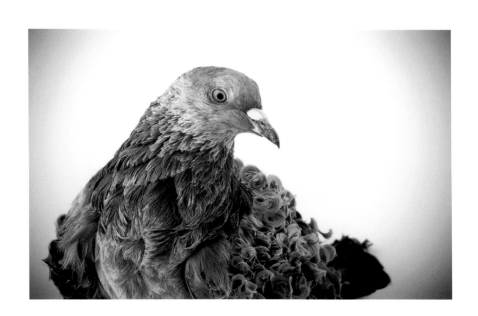

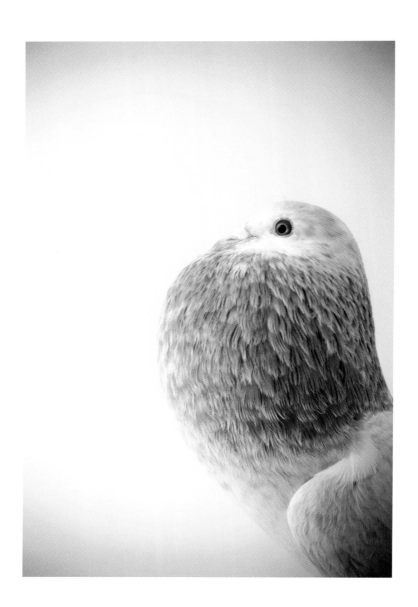

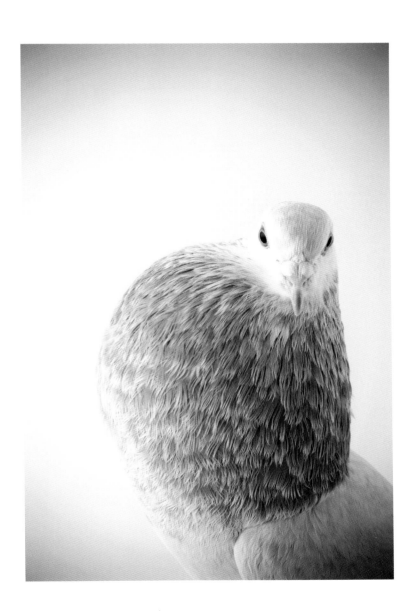

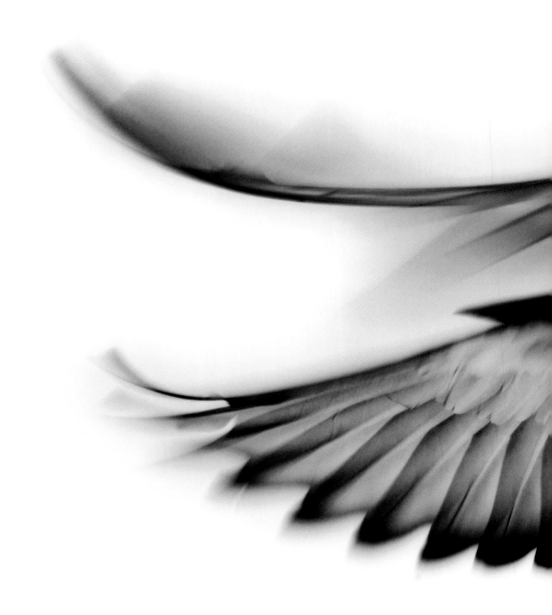

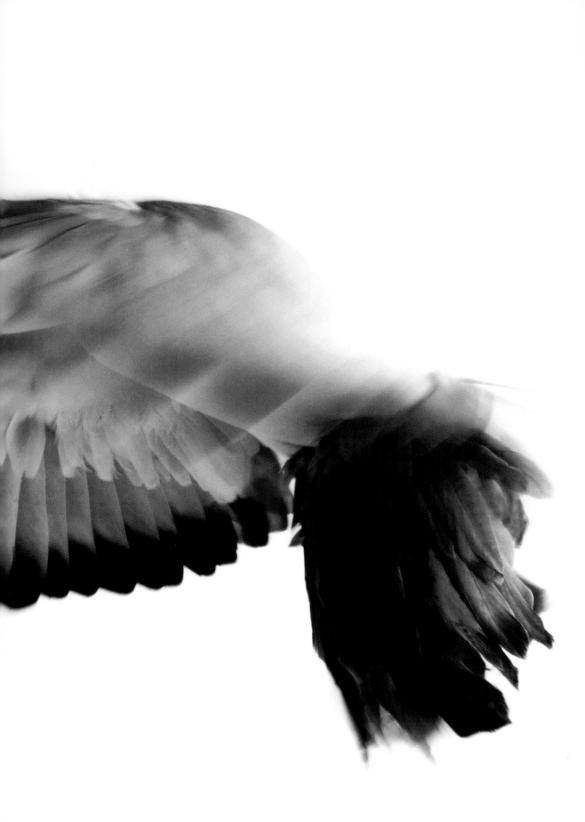

Guide to Plates.
In order shown: